SEASONS & SYMBOLS

SEASONS & SYMBOLS

a handbook on the church year

by

Robert P. Wetzler

and

Helen Huntington

Illustrations by

Helen Huntington

AUGSBURG PUBLISHING HOUSE

Minneapolis, Minnesota

SEASONS AND SYMBOLS

Copyright © 1962 Augsburg Publishing House

All rights reserved

Library of Congress Catalog Card No. 62-9094

MANUFACTURED IN THE UNITED STATES OF AMERICA

PREFACE

As Christians, we are surrounded by a great cloud of witnesses, some living, others long since dead. A true picture of the church goes beyond congregation, denomination, or even time. One of the points of genius of the church year is that it is an on-going pageant, bringing to mind those historic events of two thousand years ago, connecting them with the history of the Jews which preceded, and the history of Christianity which resulted. The church year, in short, associates us with God's activity and with that mighty cloud of witnesses which has gone before us, inspiring us to be Christ's mighty arm against the foe in our own time. The church year is a pageant, yet more than a pageant. It is life itself—life in Christ unfolded before us in a comprehensible sequence packed with meaning. It stirs us to richer worship experiences and more effective action in our mandate to preach the Good News to every creature.

Further, the church year guarantees a balanced diet in emphasis throughout the year. Without it, there would be an unconscious tendency toward certain emphases which are locally appealing. Churches showing concern about the church

1

year will find themselves in the mainstream of Christian life and thought.

Finally, but not least, the church year has a way of unifying Christendom in our own times. It is one significant bridge across the chasm between groups which otherwise find themselves on opposite steeps.

The approach taken here, relating symbols to seasons, would seem a logical one, since many symbols grew out of the same events which are recalled throughout the church year. The moods and meanings of the symbols are varied and rich. While the language of representational art is familiar to most people, the language of symbolism is somewhat different. In contrast to representation, the purpose of symbolism is not so much to show the animal, plant, or object itself, but to lead *through* these things to another deeper thought or idea. Thus the intention of symbolism is never, for instance, to represent a woolly lamb as such, but to call to mind the Lamb of God. Since they are to function in this manner, symbols tend to be a little stylized lest they lead the observer back to the world of senses rather than on to the thoughts, ideas, or situations for which they stand. Too realistic a rendering of a woolly lamb, for example, might lead one to thoughts of barnyards, pastures, or pets. The symbolic lamb, on the other hand, begins to call to mind Christ's sacrifice for our sake, his triumph over sin and evil, and his ultimate judgment.

It must be pointed out in passing that many of the symbols grouped under particular seasons would be suitable at other times as well. Some of the familiar symbols have been omitted, due in part to their familiarity, in part to their general nature which defies categorizing in any one season, and in part to limited space in keeping this within the bounds of a handbook.

It is hoped that the seasons and symbols discussed here will encourage the reader to take full advantage of the rich resources the church provides, giving added depth to his worship experience.

CONTENTS

An appropriate Advent symbol is the Tau Cross. It is simply a Latin Cross with the upper arm missing. The name Tau comes from the cross's resemblance to the Greek letter T, but the figure itself is of much more ancient origin in that it is said to have been the form of the staff which Moses raised up in the wilderness (Numbers 21:4-9). Other names for this symbol are Cross of the Old Testament, Prophetic Cross, and Anticipatory Cross. These names indicate its use in connection with the foreshadowing of Christ, his advent, and the cross of his crucifixion. Besides its use as a symbol, it is also the form on which the two thieves appear in many representations of the crucifixion.

ADVENT

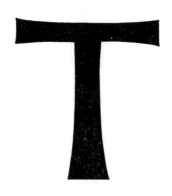

T

Length:

Advent, the first season of the church year, begins with the Sunday falling upon or nearest St. Andrew's Day, November 30th. The length of the season varies from 22 to 28 days, ending on Christmas Eve. There are always four Sundays in Advent.

Origin:

The early Christians, following Jewish customs, celebrated the beginning of the year in the spring. However, in the fourth century Christmas was introduced as a religious festival, and Christians began using this new feast to mark the beginning of the year.

Advent seems to have grown out of an early Christian practice having to do with a fasting period for candidates who were to be received into the fellowship on Epiphany, January

6th. With the introduction of the new festival, Christmas, this period of preparation was prefixed to Christmas and developed into a general period of preparation for everyone.

At first the length of this period varied considerably—from three to as many as seven weeks. But eventually Advent became a season established at four Sundays and came to mark the start of the church year as well.

General Character:

Advent, like Lent, is considered a period of penitence in preparation for the coming of the King. Advent means *coming,* generally in at least three senses: (1) the coming of Christ in the flesh, to be commemorated at Christmas; (2) the coming of Christ in Word and Spirit, to be pondered throughout the church year; (3) the coming of Christ in glory at the end of time.

The keynote of the season is sounded in the Gospel appointed for the first Sunday in Advent:

> *Tell the daughter of Zion,*
> *Behold, your king is coming to you,*
> *humble, and mounted on an ass,*
> *and on a colt, the foal of an ass.*
>
> MATTHEW 21:5

Color:

The early church apparently used white throughout the year. Indeed, not much thought was given to other colors until a much later time. Clear references to other colors do not appear until the twelfth century when red was referred to as a color for Pentecost.

It is not certain whether colors were chosen arbitrarily and later given symbolic reference, or whether they were chosen with a symbolic idea in mind. The latter is probably true, since, consciously or unconsciously, certain colors seem to create

particular feelings from nature. For example, white is clean and pure. Green is growth and spring. Black is dreariness, night, or dark clouds. Red is fire or blood. Violet, the most arbitrary choice of the various liturgical colors, bears the meaning of penitence and mourning.

The proper color for Advent, then, is *violet*, signifying a period of penitence and preparation for the coming of the King.

Since the liturgical colors signify seasons of the church's corporate life in Christ, a clear statement about their usage is often made such as this from the Lutheran *Service Book and Hymnal*, page 276: "The Celebration of the Holy Communion, or the use of any of the Occasional Services, including the Order for Marriage, and the Order for the Burial of the Dead, shall not affect the Proper Color for the Day or the Season."

Symbols:

There are many symbols for Christ which may be called prophetic symbols because they are drawn from the words of the prophets and which would be fitting for use during Advent. Not all of the symbols which stem from the prophetic writings are shown here. Many more may be found by reading the writings of the prophets whose imagery is so easily translated into visual symbols. Such symbols bring to mind the prophecies of Christ's appearance, the long expectation, the preparation, and the promise. Therefore they serve as springboards for meditation on his coming and mission.

The use of the scepter or king's staff as a symbol for Jesus is based on a quotation from Numbers 24:17 which reads:

> I see him, but not now;
> I behold him, but not nigh:
> a star shall come forth out of Jacob,
> and a scepter shall rise out of Israel.

The usual form for the scepter is that shown in the illustration— a long staff terminating in an orb crowned with a cross. Here the scepter has been combined with the kingly crown to suggest the kingly office of Jesus. It may also be shown displayed on a shield.

■

A sun form is another of the prophetic symbols for Jesus. Its use is based on the familiar quotation from Malachi 4:2, "But for you who fear my name the sun of righteousness shall rise, with healing in its wings." In order to identify the sun as a Christ symbol, a monogram has been placed in the center. The IHC used here is the abbreviation of the Greek word IHCOYC which means Jesus. The little bar which makes a cross of the H is a sign that this is an abbreviation. IHS is often used. This is an abbreviation of the Greek word IHΣOYΣ, the same word as above only in a different style of lettering.

■

Zechariah 3:8, "Behold, I will bring my servant the Branch," is one of several quotations from the prophetic writings which explains the use of the branch as a symbol of Jesus. In the eleventh chapter of Isaiah, the branch is spoken of as growing from the roots of Jesse. This has led to a symbol known as the Jesse Tree (not shown), which is a stylized tree growing out of Jesse on which descendants appear. The Madonna and Child appear at the top of the tree.

8

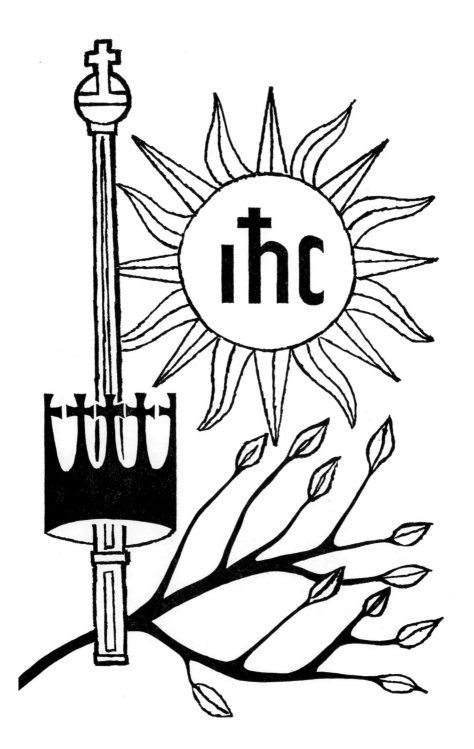

Another quotation from Zechariah is the basis for the use of the fountain as a symbol for Christ: "On that day there shall be a fountain opened for the house of David and the inhabitants of Jerusalem to cleanse them from sin and uncleanness" (Zechariah 13:1). The New Testament, too, makes use of water as a symbol signifying rebirth and the washing away of sin. This symbol has been well used in these words from a familiar hymn: "O fount of grace redeeming, O river ever streaming. . . ."

■

One of the most important prophetic symbols is the Serpent of Brass. Its use is based on the story of the serpent which Moses raised up in the wilderness (Numbers 21:4-9). Jesus himself recognizes this incident as a type of his crucifixion when he says, "And as Moses lifted up the serpent in the wilderness, so must the Son of man be lifted up, that whoever believes in him may have eternal life" (John 3:14-15). Some of these prophetic symbols may seem too suggestive of the crucifixion for use during Advent. Yet it must be borne in mind that we who know the whole story find it impossible to isolate one phase of Christ's life from the full scope of his mission and its accomplishment.

■

Another Advent symbol is the scroll which shows the words of Isaiah's prophecy in Latin: Ecce Virgo concipiet et pariet Filium— "Behold, a virgin shall conceive and bear a son." St. Matthew quotes this prophecy in the first chapter of his Gospel.

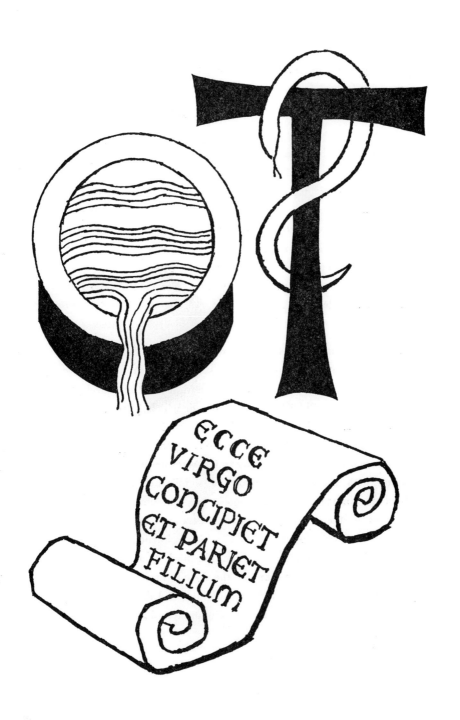

ECCE VIRGO CONCIPIET ET PARIET FILIUM

God's promise to Abraham may be shown very simply by using many small stars together with one large one representing the Messiah.

■

The rose has been used to refer symbolically to many things. The Messianic Rose which is shown here derives its meaning from the thirty-fifth chapter of Isaiah (KJ) where it is stated that the desert shall blossom as a rose at the coming of the glory of God. The rose may also symbolize the nativity; a white rose or mystic rose, the Virgin; a red rose, martyrdom or divine love; a rose on the cross, the death of Christ. The rose also symbolizes love and reminds us during Advent of the words, "For God so loved the world . . ." (John 3:16).

■

The symbol made up of two doves and a Chi Rho is included here because it represents human souls meditating on Christ. However, it is a symbol which may be used at any time during the church year. The Chi Rho is a monogram which is the abbreviation of XPICTOC, the Greek word for Christ. Birds are often used to represent the soul because of the bird's general appearance of coming from the air and returning to it. Doves are also used in connection with vines (not shown), the significance being that of Christians abiding in Christ. Peacocks are sometimes used instead of doves in these instances. Sometimes doves or peacocks are represented as drinking from a vase, which is intended to represent the partaking of the Water of Life. The birds themselves suggest secondary meanings. For example, the dove in itself may symbolize peace, purity, meekness, modesty, humility, and divine inspiration. The peacock has the secondary meaning of eternal life, resurrection, and immortality.

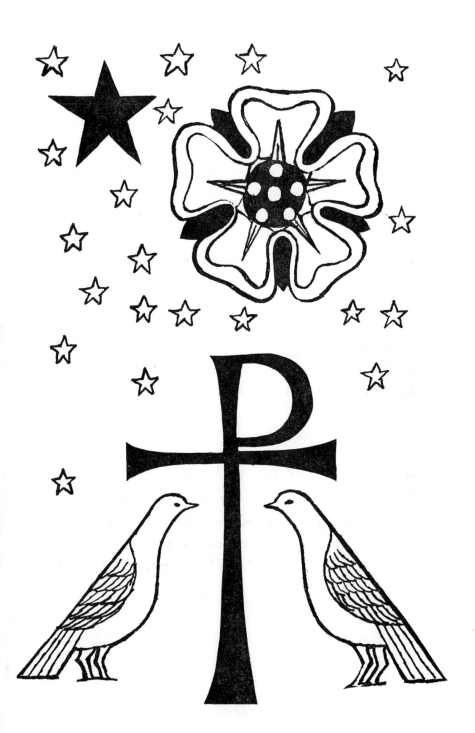

St. John the Baptist, who preached so zealously of repentance and preparation for the coming of the Lord, is of interest during Advent. Three symbols for St. John are shown here, all of which would appear emblazoned on shields in the fashion of a coat of arms. The first of these, the locust and honey, refers to John's life in the wilderness (Matthew 3:1-6; Mark 1:4-6). A locust and leather girdle are frequently seen and are based on the same references.

■

Ecce Agnus Dei—John's words, "Behold, the Lamb of God" (John 1:29), inscribed in Latin upon a scroll, are a fitting symbol for him and memorable words for the Advent season.

■

Jesus is often spoken of as the Lamb of God in the prophetic writings of the Old Testament and in various places in the New Testament, including the Book of Revelation. But it was John who pointed out Jesus as the Lamb of God. Therefore, when this symbol appears on a shield and in proper context, it refers to St. John the Baptist. The Lamb triumphantly carries the banner of victory over sin and death.

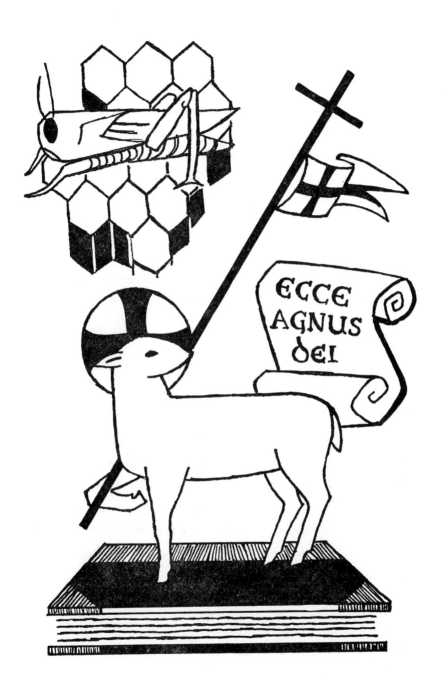

The Ansate Cross, or Looped Cross, is an ancient Egyptian symbol denoting life. Taken over into Christian art it retained its meaning of life and regeneration. This cross form is that of the Prophetic Cross (shown at the beginning of the chapter on Advent) with an added element transforming it into a symbol of life, reminding us of the prophecies which became reality with the birth of Jesus.

CHRISTMAS

Length:

December 25th is, of course, Christmas Day. Christmas Day, like Easter Day, is preceded by a period of penitence and fol-, lowed by a season of joy. The Christmas season begins with vespers on Christmas Eve and ends with vespers on the eve of Epiphany.

Origin:

The early church did not have Christmas as we know it today. Both the birth and baptism of Jesus were commemorated on Epiphany, January 6th.

Christmas developed from a pagan festival celebrating the birth of the sun-god. On the first day of winter, the shortest day of the year, the sun-god is said to have had a "rebirth." For from that day on, the length of the appearance of the sun increases each day. In our own times this day normally falls

on December 21st. However, in the fourth century it occurred on December 25th.

It is not surprising to learn that the Christians found here a striking parallel, symbolically, to the Sun of Righteousness. Therefore this festival was taken over by the Christians and became instituted at Rome sometime in the first half of the fourth century. From Rome this new festival spread slowly to other parts of Christendom until it gradually overshadowed Epiphany.

Scholars differ in their dating of the birth of Jesus. Many feel that Christ was born in 4 B.C. or earlier. Luke refers to an enrollment imposed by Augustus as the occasion for the journey of Mary and Joseph to Bethlehem. Outside sources give evidence of an enrollment by Quirinius in 6 A.D. which provoked a desperate uprising. However, scholars consider 6 A.D. to be too late since Herod the Great undoubtedly was living at the time of Christ's birth (Luke 1:5), and Herod died in 4 B.C. Lack of actual historical evidence and errors in the calendar, therefore, lead to the conclusion that the day, month, or even year of Christ's birth cannot be known.

General Character:

Advent began with the heralding of Christ's first coming: "Tell the daughter of Zion, Behold, your king is coming to you . . . " (Matthew 21:5). The second Sunday in Advent referred to Christ's second coming when "there will be signs in sun and moon and stars . . . men fainting with fear and with foreboding of what is coming on the world . . . " (Luke 21: 25-26). Then on the third Sunday, the lesson told of John the Baptist in prison sending his disciples to Jesus with the query, "Are you he who is to come, or shall we look for another?" (Matthew 11:2-3). In answer, Jesus verified that he was indeed the Messiah by pointing out the works of mercy he was doing. And then on the final Sunday in Advent, John told of Jesus "who comes after me, the thong of whose sandal I am not

worthy to untie" (John 1:27). Advent leaves us standing at the threshold of Christmas.

Christmas comes, then, as a season of great joy, marked by such passages from Scripture as, "For to us a child is born, to us a son is given; and the government will be upon his shoulder, and his name will be called 'Wonderful Counselor, Mighty God, Everlasting Father, Prince of Peace'" (Isaiah 9:6). The keynote of the season is also given in the song of the angels: "Glory to God in the highest, and on earth peace among men with whom he is pleased!" (Luke 2:14).

Color:

The color for the Christmas season is *white*. The exceptions would be two special days when *red* is used: St. Stephen, Martyr, December 26th; and The Holy Innocents, Martyrs, December 28th. The day for St. John, Apostle, Evangelist, December 27th, retains white as its appointed color since John is said to be the only apostle who died a natural death.

Symbols:

It may seem strange to us, to whom Christmas is such an important and well-observed day, that symbols for the nativity are not numerous. This may be due, in part, to the fact that the actual scene of the nativity has so caught the imagination of artists that it is more frequently presented pictorially than symbolically. Some of the symbols of the season have a secular origin or an origin which is lost in tradition and legend. Nativity symbols which have come down to us with any satisfactory explanation are not as frequently used as are symbols for some of the other seasons or days of the church year. Again, this is probably due to the popularity of the nativity scene itself which is often the chief decoration of the church at Christmas.

The blossoms of the Glastonbury Thorn, which appear at the top of the page opposite, are symbols of the nativity. The Glastonbury Thorn Tree, which stands within the gates of the ruined abbey at Glastonbury, Somersetshire, England, is supposed to be a descendent of the thornwood staff planted by St. Joseph of Arimathaea. St. Joseph is said to have introduced Christianity to England in 63 A.D. At any rate, there seem to be good reasons for believing that Christianity in Britain has a very long tradition, and that it is possible that this thorn tree was planted by early missionaries. The use of the blossoms as a Christmas symbol derives from the observation that the Glastonbury Thorn blooms about Christmas Day each year.

■

The poinsettia, which appears in profusion in Christmas decoration, is regarded by some as having the same meaning as the Christmas Rose. It seems, however, that its use as a symbol stems from a secular origin. Its popularity may be due as much to the decorative effect of the brilliant red blossoms as to anything else.

■

In the third chapter of Exodus, God speaks to Moses from a burning bush. Medieval churchmen paralleled God's descending to man in a burning bush with God's descending to man as a new-born child. The burning bush thus became a nativity symbol. Although many of the parallels the ancient church found between the Old and New Testaments seem involved and difficult, this one seems quite apt. Through a more involved train of thought, the burning bush has symbolized the Immaculate Conception and as such appears beneath the feet of Mary in some French cathedrals.

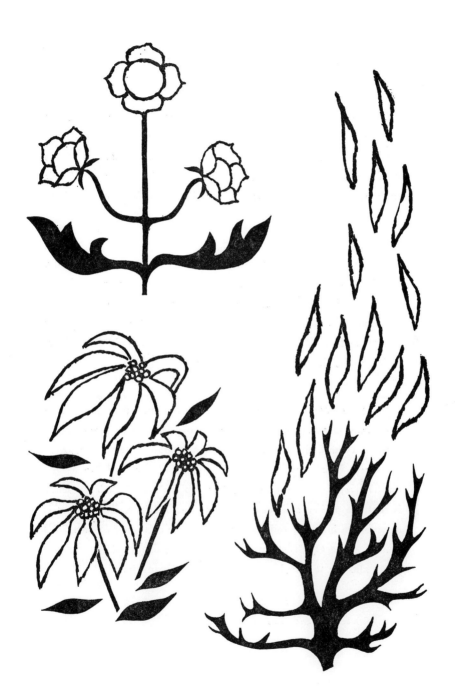

Reference to the familiar Christmas story is again evident in the use of shepherds' crooks as a symbol for the nativity. The shepherds, who went hastily to see the Child about whom the angels spoke, complete the picture of the nativity in our minds. Their staffs also remind us of the Christ who called himself the Good Shepherd.

■

A manger such as the one shown is another symbol of the nativity. Although this manger is surely not the type in which the Christ Child rested, it has become the one used when a symbolic representation is desired. It may be shown either with a nimbus (a circular form about the head) indicating that the child is within, or it may be shown as an empty manger.

■

Since medieval times an ox and an ass have been included in Christmas scenes. Although there is no reference to them in the Gospel account, the reasons for their appearance may be found in prophecy. Isaiah says, "The ox knows its owner, and the ass its master's crib" (Isaiah 1:3). Another explanation of their presence is that the ox is a symbol of patience and sacrifice, and the ass is a symbol of humility and service. Again, the ox's role as a sacrificial animal in the Old Testament prompts some to regard its presence as an allusion to Israel and Old Testament worship.

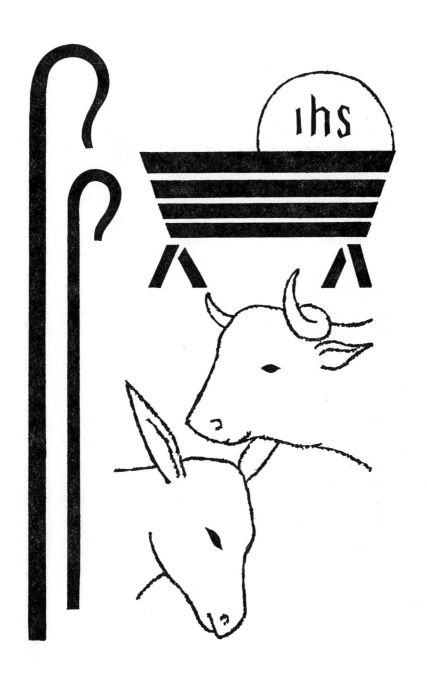

An angel whose hand is raised in benediction is another symbol of the nativity. The story of the nativity as we read it in St. Luke is so familiar that angels seem to be an inseparable part of Christmas. This symbol brings to mind the words of the angel, "Be not afraid; for behold, I bring you good news of a great joy which will come to all the people; for to you is born this day in the city of David a Savior, who is Christ the Lord" (Luke 2:10-11). This story also suggests joyous angels praising God. When used as a symbol of praise they are shown playing on musical instruments such as the lyre.

■

Scenes of the nativity strive to give, in painted or sculptured form, some suggestion of the beauty and innocence of the newborn Savior. The innocence of the Christ Child has also found expression symbolically in the conventionalized form of the daisy. Although there is no scriptural basis for this symbol, few would dispute the idea that there is something about the daisy which suggests innocence. Perhaps the simplicity and fresh appearance of this flower have made it so universally symbolic of innocence in both religious and secular use. The white color also gives the connotation of purity, innocence, and cleanliness. All white flowers, such as the lily, the lily of the valley, and the white rose give symbolic meanings consistent with this idea.

■

The fleur-de-lis is thought by many to be a very conventionalized form of the lily. In relation to the nativity it is used to symbolize the human nature of the Savior. In other instances it is a symbol for the Virgin Mary and for the Trinity.

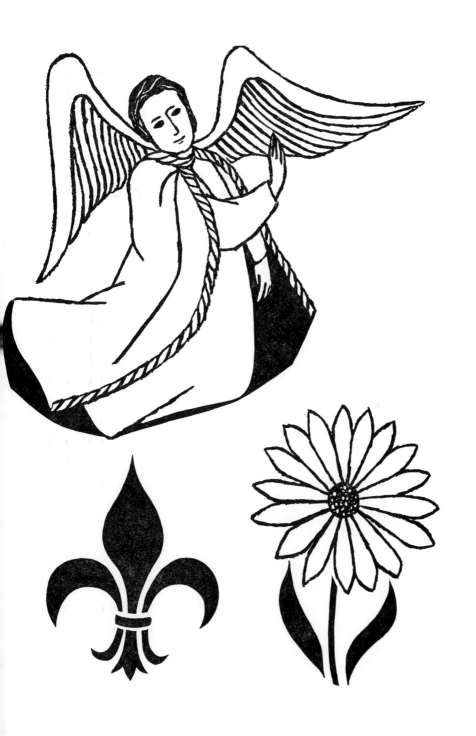

The Cross Crosslet is composed of four Latin Crosses arranged in such a manner that their bases overlap. Because of the missionary emphasis of Epiphany, it suggests the old idea of the four corners of the earth and the spreading of the Gospel (represented by the crosses) throughout the world.

EPIPHANY

Length:

January 6th is Epiphany Day. This day is followed by a season which varies in length, depending on the date of Easter. An early Easter means a short Epiphany season, and vice versa. The difference created in the length of the year is compensated for in the Trinity season. A short Epiphany, for example, would mean a proportionately longer Trinity season. The Epiphany season can be anywhere from one to six Sundays in length, ending with vespers on the eve of Septuagesima.

Origin:

With the exception of the Easter season, the Epiphany of our Lord is the oldest festival of the church year. Epiphany was originally a pagan festival to the sun-god which was taken over by the Christians and packed with new meaning. This pagan festival celebrated the birth of Aeon in the night be-

27

tween January 5th and 6th. In 2000 B.C., the first day of winter occurred on January 6th. From that day on the sun appeared longer each day, so this was a natural time to celebrate the birth of the sun-god. Eventually, due to errors in measuring time, the first day of winter shifted to an earlier date, but January 6th was retained as the date for this festival.

By the fourth century B.C., the first day of winter occurred on December 25th, and a new pagan sun-festival was instituted on this date. Christmas later replaced this latter festival, as was noted in the chapter under Christmas. Both Christmas and Epiphany, then, originated from a sun-festival held on the first day of winter. The first day of winter now normally occurs on December 21st, but the festivals emerging from previous winter solstices remain as they were.

General Character:

The word Epiphany means *to show*. In its root form the word was often used to describe the dawn and the appearance of gods coming to men. *Manifestation* is another word used to describe the meaning of Epiphany. It is the manifestation of the glory of God in sending Christ into the world. Epiphany has also been called *Theophany*, meaning the appearance of God, the *Feast of the Manifestation,* the *Feast of Lights,* and the *Feast of the Appearing of Christ.*

Until the institution of Christmas in the 4th century A.D., both the birth and baptism of Jesus were commemorated on Epiphany. With the celebration of Christ's birth at Christmas, the Eastern Church restricted Epiphany to the celebration of the baptism of Christ. This seems to be the emphasis Luther would have preferred.

In the Western Church, on the other hand, Epiphany be-came associated with the coming of the Wise Men. The reason for this is not clear. Since the Wise Men were not Jews, the importance of the message of Epiphany deals with the mani-

28

festation of Christ to the Gentiles. Therefore, the Epiphany season has become a time for emphasis on the missionary task of the church.

Color:

The color for the Epiphany season is *white*, signifying light, purity, brightness. Exceptions would be Saints' Days falling within this period of time, when *red* is used.

Symbols:

Epiphany symbols generally relate either to the Wise Men or to the idea of the spreading of the Gospel. The Wise Men may be considered as symbolic of the Gentiles who were ultimately to receive the Gospel. It is interesting to note that very little is said concerning the Magi in St. Matthew's account of their visit to the Christ Child. However, legend fixed their number at three and their names as Jasper, Balthasar, and Melchior. Also as a result of legend and story they became not only wise men but kings. The legends concerning the Magi are now so entrenched in custom and tradition that they affect the rendering of symbols relating to them.

St. Matthew's Gospel states that the Magi did not go directly to Bethlehem but went first to Jerusalem where they inquired about the Messiah, "Where is he who has been born king of the Jews? For we have seen his star in the East, and have come to worship him" (Matthew 2:2). Being told that the prophets had spoken of Bethlehem, they proceeded there and found the mother and Child, not in a manger as in the Lukan account, but in a house. Thus the five-pointed star so frequently associated with the nativity is actually proper to Epiphany. It symbolizes the manifestation of Christ to the Gentiles.

■

Three caskets, or chests, are also used to symbolize Epiphany. Their reference is to the gifts presented to the Holy Child—gold, frankincense, and myrrh. These gifts in turn have their symbolism. Gold represents Christ's kingly office, frankincense represents his priestly office, and myrrh represents his prophetic office.

■

Three crowns are another symbol for Epiphany. In this case, the number three and the suggestion that the Wise Men were kings is based on the popular legends concerning the event of their visit which were current during the Middle Ages.

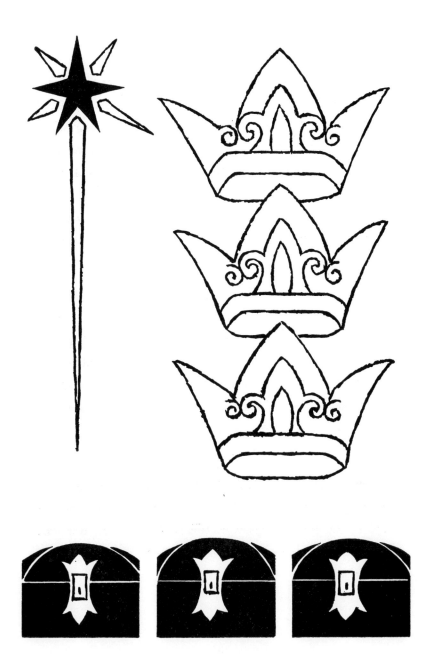

With the manifestation of Christ, a new relationship between God and man begins. Jesus is called Emmanuel, which means God with us. Although not specifically symbolic of Epiphany, the vine and branches symbolize this new relationship and give added meaning to the joy of the season. Jesus said, "I am the vine, you are the branches. He who abides in me, and I in him, he it is that bears much fruit, for apart from me you can do nothing" (John 15:5). Then he adds, "As the Father has loved me, so have I loved you; abide in my love" (v. 9).

■

An orb, representing the world, is surmounted by a cross, symbolizing the triumph of the Savior over the sin of the world. It signifies clearly the conquest of the world by the Gospel through Word and Sacrament. This symbol is familiar and widely used. Its message is especially appropriate to the Epiphany season.

■

Christ's baptism, symbolized by the shell and drops of water, is brought to mind during Epiphany in connection with the idea of the proclamation of Christ's divinity: "Lo, a voice from heaven, saying, 'This is my beloved Son, with whom I am well pleased'" (Matthew 3:17). The shell and water also symbolize Baptism in general.

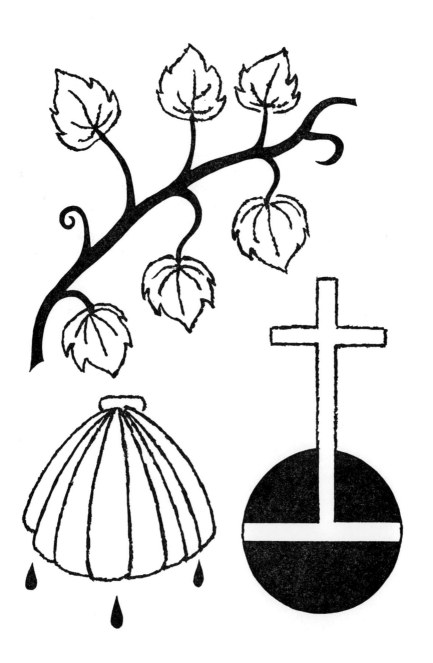

Because of the nature of this season, no particular cross form relates directly to it. Used here is the Cross Patée, one of fifty or more decorative forms of the cross which have been used in Christian art. As shown, the arms of this cross are narrow at the center and expand toward the ends.

PRE-LENT

Length:

The Pre-Lenten season extends three and one-half weeks from Septuagesima Sunday to Ash Wednesday. The Sundays in this season are called Septuagesima, Sexagesima, and Quinquagesima, meaning seventy, sixty, and fifty, respectively. The calendar date of Septuagesima Sunday is variable, depending on the dates of Easter and Ash Wednesday. It can fall as early as January 18th or as late as February 22nd.

Origin:

The origin of this brief season is quite obscure. It arose from the Roman Church and may have grown out of preparatory fasts for monks. From Rome the observance of Pre-Lent spread over the entire Western Church.

Before the middle of the sixth century the entire Lenten season was called Quadragesima, meaning forty days. The Sun-

days before Lent, then, were named by analogy: Quinquages-ima, meaning fifty days; Sexagesima, meaning sixty days; and Septuagesima, meaning seventy days. These names are not precise, however, for our weeks have seven and not ten days. Quinquagesima is the only one of these days with an accurate title, for it occurs exactly fifty days before Easter.

In the Roman Catholic Church this season functions as an extension of Lent. Violet is the color used, and both the *Alleluia* and the *Gloria in Excelsis* are omitted from the liturgy.

In the Protestant Church, however, there is resistance to extending the Lenten season, which is already forty days in length. Green is usually retained as the color of this season to avoid the idea of Lenten penitence. All three of the Sundays in Pre-Lent are regarded as major festivals in the church calendar. However, alleluias are often omitted from the introits and graduals during this season.

General Character:

As pointed out above, the Protestant Church has avoided the Roman Catholic idea of extending the long Lenten season. The general character of this season, therefore, seems to be simply a short season leading into Lent.

The last days of this period, between Quinquagesima and Ash Wednesday, have often been considered a time for celebration before Lent. The day before Ash Wednesday, Shrove Tuesday (from *shrift*, or confession), was a time for carnivals in the Middle Ages. The Italians would wear masks and enact folk comedies such as *Scaramouch*, or *Punchinello*. The Germans celebrated with beer, pretzels, and huge sausages. Two Shrove Tuesday customs, doughnuts in Germany and pancakes in England, were probably introduced to use up grease, the use of which was prohibited during Lent. The French celebrated by leading an ox through the street on the way to be barbequed. The *Mardi gras* festival, held each year in New Orleans, is a carry-over of this French celebration.

Color:

The color for the Pre-Lenten season is *green* in the Lutheran Church, *violet* in the Roman Catholic Church. Although the Anglican Church does not regard this season as an extension of Lent, it retains the use of *violet* signifying penitence.

Symbols:

Since no symbols are expressly indicated for Pre-Lent, the use of any which do not bear specific reference to other seasons is permissible. Of the many, many Christian symbols whose meanings have to do with basic teachings of the church, perhaps those based on the words of Christ are the most meaningful and least restricted in use. The Vine, the Bread of Life, the Good Shepherd, and the Light of the World are a few. Others are suggested by the imagery of the Gospels.

The Passion Cross is distinguished by the pointed ends on the arms. It is also known as the Cross of Suffering, Cross Urdée, or the Cross Champain. Symbolically it indicates Maundy Thursday or Good Friday.

LENT
&
HOLY WEEK

Length:

The Lenten season extends over a forty-six day period beginning Ash Wednesday and ending on the eve of Easter. The six Sundays in Lent are not actually a part of Lent, and therefore the Lenten season itself is forty days. Sundays, being weekly commemorations of the first Easter, have always been excluded from this fast season. The date of Ash Wednesday is determined by the date of Easter.

Holy Week is the last week in Lent, beginning with Palm Sunday. It is given special attention because of its significance as a review of the events of the Passion of Christ.

Origin:

Lent developed from two sources. The first was a period of fasting which preceded Easter in the early church. At first, this period of fasting was held only on Saturday, the day before

Easter, lasting until 3 A.M. Easter morning when the Eucharist was celebrated. This called to remembrance the fact that Christ rose from the dead early in the morning. Later this fast was extended to six days and eventually became separated into the events of Holy Week. Holy Week, then, is an older season than the entire Lenten season.

The second source for this season of Lent was the Baptism of candidates into the faith on the eve of Easter. Since the early church was an "underground movement," candidates were carefully screened, and there was a long period of preparation. The strictest part of this probationary period came, as would be expected, just before the time of Baptism. A fasting period of forty days was required, the length of which was suggested by our Lord's fasting in the wilderness, Moses' fasting at Mt. Sinai, and Elijah's fasting on the way to the Mount of God—each forty days. Eventually, this period of preparation for Baptism evolved into a general period of preparation for Easter to be observed by all Christians.

The word *Lent* probably comes from the Anglo-Saxon *lencten,* meaning spring, and the German *Lenz,* meaning the time when the days lengthen.

General Character:

The Lenten season, then, is a period of penitence in preparation for the highest festival of the church year, Easter.

There seem to have arisen, however, two misunderstandings about the Lenten season. First, the penitential tone of the season has crept into the Sundays within the season, obscuring them as commemorations of the first Easter.

Second, the days of Lent themselves seem to have become dominated by meditation on the sufferings of Christ and sometimes even by morbid introspection. A study of the Passion of Christ is often extended over the entire Lenten season. The study of the Passion, however, is the special subject of Holy Week. Edward T. Horn III states in his *The Christian Year:*

"Sermons and meditations at midweek Lenten services are usually concerned with the events and characters of the Passion. Often the result is that, by the time Holy Week arrives, both people and clergy are weary of the details of the narrative which is proper to the week before Easter."[*]

Certain days of Holy Week have been given special significance. The first is Palm Sunday which takes it name from Jesus' triumphal entry into Jerusalem. In medieval days there was a ceremony of blessing the palms followed by a procession. This is still observed in the Roman Catholic Church, and some Protestant Churches, too, recall that historic event with a procession of palms.

Thursday in Holy Week is the anniversary of the institution of the Lord's Supper which was held the evening before the crucifixion. The name Maundy Thursday is derived from the Latin *mandatum*, meaning command, referring to the footwashing ceremony at the Last Supper, when Jesus spoke of the "new commandment" to love one another as he himself had loved (John 13:1-35).

Friday in Holy Week, of course, is the anniversary of the crucifixion. The term *Good* Friday probably came from "God's Friday" just as *good-by* comes from "God be with ye."

Color:

The color used during Lent and Holy Week is *violet*, indicating a penitential period. *Black* is used on Good Friday.

Symbols:

Little in the way of symbolism has grown up in connection with Lent as a whole. On the other hand, so many symbols pertaining to Holy Week exist that it has been possible to present only a small part of them here.

[*]Horn, Edward T. III. *The Christian Year*. Philadelphia: Muhlenberg Press, 1957, p. 103.

The symbol at the top of the page is proper to Palm Sunday. The element of the cross and orb is already familiar to the reader (see page 32) and retains the same meaning in this use. Coupled with the palm leaves which were strewn in front of Christ as he entered Jerusalem, the symbol suggests Palm Sunday and its significance. Palm leaves, in addition to their connection with this event, symbolize victory.

■

Coupled with a chalice as shown here, the Passion Cross is symbolic of the agony of Gethsemane.

■

Grapes and wheat are very familiar as a symbol of Holy Communion, the grapes indicating wine, and the wheat, bread. Here they represent the Last Supper.

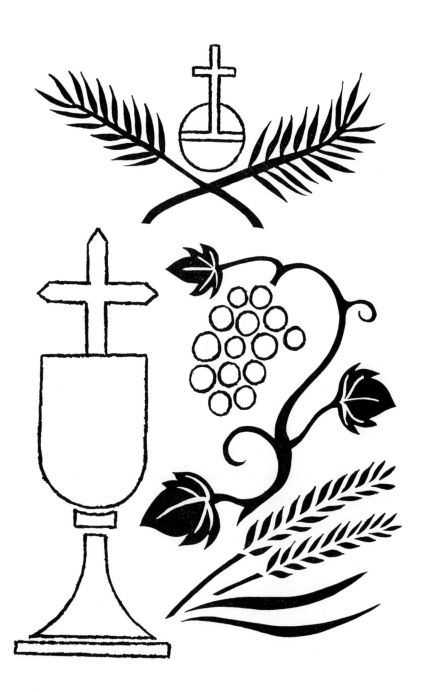

Almost every event leading up to the crucifixion has its symbol. The story is so familiar to Christians that the whole of it can be told by the use of these "visual aids." The few shown here will suggest many more whose bases are easily found in the Gospel accounts. For instance, the purse with a few coins issuing from it is easily recognized as indicating the thirty pieces of silver for which Judas betrayed Christ. It is a frequently used symbol of the betrayal.

■

Another symbol of the betrayal is based on John 18:3: "So Judas, procuring a band of soldiers and some officers from the chief priests and the Pharisees, went there with lanterns and torches and weapons." A lantern is shown here. A torch crossed with a club or sword is also used to symbolize the betrayal (not shown) and is based on the same passage.

■

A crowing cock suggests the trial and condemnation of Christ and is used specifically in reference to Peter's denial of Jesus. This symbol reminds each Christian of his responsibility to "always be prepared to make a defense to any one who calls you to account for the hope that is in you . . ." (1 Peter 3:15).

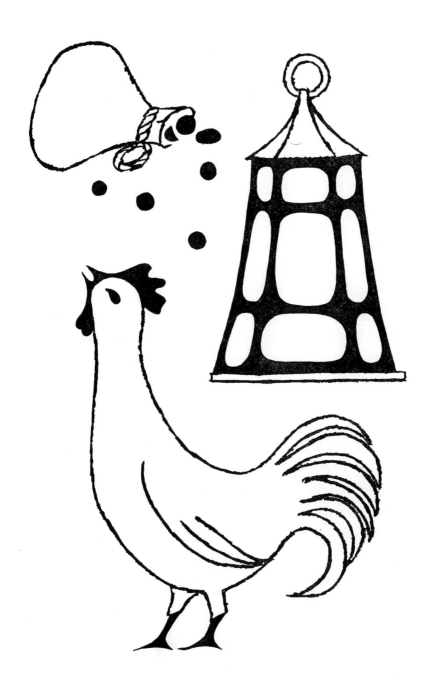

Scourges and a pillar are representative of the trial and condemnation of Christ in reference to this passage: "Then Pilate took Jesus and scourged him" (John 19:1). The type of pillar shown is merely traditional, as it was supposed that this was the type to which Christ was tied.

■

The crown of thorns combined with the nails used to fasten Jesus to the cross needs little explanation. There seems to be no explanation for the tradition which fixed the number of nails at three. Until the end of the twelfth century, representations of the crucifixion show Christ nailed to the cross with four nails. From the thirteenth century on, only three nails are shown, and this tradition persists in symbolism today.

■

"So when Pilate saw that he was gaining nothing, but rather that a riot was beginning, he took water and washed his hands before the crowd, saying, 'I am innocent of this man's blood; see to it yourselves.' And all the people answered, 'His blood be on us and on our children!'" (Matthew 27:24-26.) The basin and ewer (widemouthed jug) symbolize this act of Pilate by which he sought to remove the guilt of Christ's condemnation from himself.

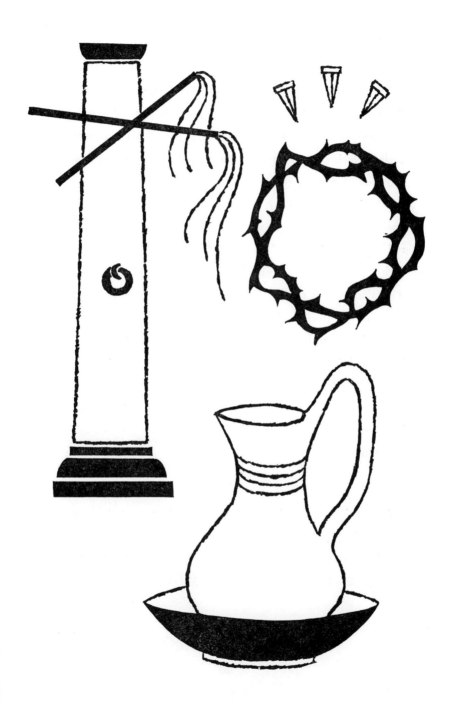

The Latin Cross appears frequently, and, as the actual form of the cross upon which Christ was crucified, is by far the most popular of all the forms in general use. It is common to all religious bodies which confess the Lord Jesus Christ and his death for our salvation. A scroll is shown attached to the top of the cross on which the letters I.N.R.I. are written. These letters indicate the Latin inscription, Iesus Nazarenus Rex Iudaeorum—"Jesus of Nazareth, King of the Jews." This inscription is shown in accordance with John 19:19-22, as follows: "Pilate also wrote a title and put it on the cross; it read, 'Jesus of Nazareth, the King of the Jews.' Many of the Jews read this title, for the place where Jesus was crucified was near the city; and it was written in Hebrew, in Latin, and in Greek. The chief priests of the Jews then said to Pilate, 'Do not write "The King of the Jews," but, "This man said, I am King of the Jews."' Pilate answered, 'What I have written I have written.'" And so this inscription appears above the cross either in Latin or in the three languages.

■

A cross designed as the one shown at the bottom of the page opposite is known as a Cross Cantonnée. It suggests the five wounds of Christ; the four small crosses, the wounds in his hands and feet, and the large one, the wound in his side.

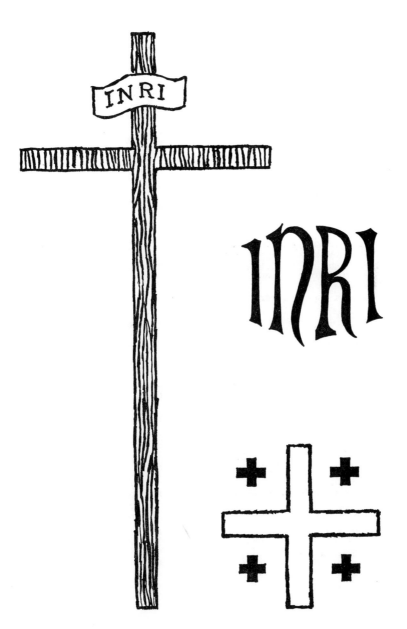

Known as the Pelican in Her Piety, the symbol shown at right had its origin in legend. There are variations of the legend, but one form states that in time of famine the pelican tears open her breast so that the young surrounding her may feed on her blood to live. Thus, it was said, the pelican brought life to her young by her death. Although the legend is probably the result of a misunderstanding of the way in which the pelican feeds its young, it offers a striking parallel to the atonement of our Savior. The symbol is still widely used today. In older paintings of the crucifixion, the Pelican in Her Piety may be seen represented above the cross.

■

Symbolic of Christ crucified and the shedding of the Savior's blood for our sake, the wounded lamb is one of three types of the Agnus Dei or Lamb of God. The lamb carries a staff in the form of a cross, and its blood flows into a chalice. It is distinguished as a member of the Trinity by the use of a tri-radiant nimbus. The other two forms of the Agnus Dei might be mentioned here in order to avoid confusion. The banner bearing the form of the lamb (which appears on the shield of St. John the Baptist) signifies the resurrection. A third form, the lamb without either banner or staff, reclining on the book of seven seals, symbolizes Christ as judge at the end of the world.

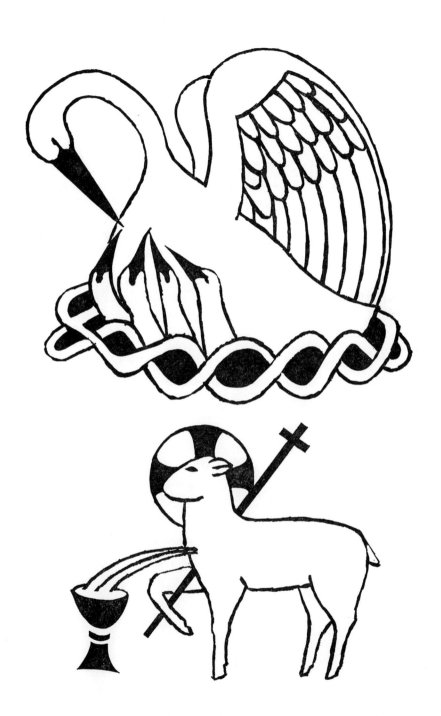

The Cross of Glory is fittingly used for Easter. A Latin Cross is coupled with the rising sun placed behind in such a way that the rays extend out from the intersection of the arms. Another familiar form of the cross at Easter is the Latin Cross decorated with lilies.

EASTER

Length:

The Easter season begins with vespers on the eve of Easter, ending with vespers on the eve of Pentecost, fifty days later. These fifty days are called the Holy Fifty Days, or the Great Fifty Days.

The movable days and festivals of the church year, with the exception of Advent Sunday, depend on the date of Easter. Easter is always the first Sunday after the first full moon falling upon or after March 21st, the first day of spring.* If the full moon occurs on Sunday, Easter is placed on the following Sunday. Easter Day can occur between March 22nd and April 25th. This method of dating Easter is to make it coincide with the feast of the Passover, since the first Easter coincided with that feast.

In recent years, there has been some discussion about stabilizing the date of Easter and fixing the length of the variable seasons. A complete calendar reform has been suggested which

*As in 1962, note that this method of dating Easter is not always precise, for Easter is still determined by an ancient ecclesiastical computation. For further details, cf. the Anglican BOOK OF COMMON PRAYER.

would place the Sundays on the same dates each year, with Easter on April 8th. This date has been suggested because it is the midpoint of the span within which Easter can now occur. Since calendar reforms are next to impossible to bring about, it would seem that this suggestion has almost insurmountable barriers against it, even though such a reform would be an excellent idea.

Perhaps a more feasible suggestion would be to narrow down the placement of Easter without involving a complete calendar reform. This could be done by placing Easter on the Sunday nearest or upon April 11th, or April 10th during leap year. This means that Easter would always occur between April 7th and 14th, and that Epiphany would be fixed at four Sundays. Trinity would then be equalized at 24 or 25 Sundays, limiting its variation to only one Sunday.

Some such arrangement would be an immeasurable asset to planning parish education and church school programs. It would mean that most of the fixed days of the year would fall within the same season each year. It would be a boon to church publication houses in the planning of materials. Businessmen, in preparing their stock, would undoubtedly welcome a more stable year also.

Origin:

Easter is the oldest festival of the church year. The period of fifty days after Easter is older than either Lent or Advent. For some time these fifty days were considered of greater significance than Lent. It wasn't until the Middle Ages that Lent took on greater emphasis than the Great Fifty Days. For some unknown reason the church has become more concerned about the lost condition of man as emphasized in Lent than the redemption of God noted during the Easter season. Henry T. Horn III feels that the church should come out of this medieval bondage to Lent and return to the promised land of Easter triumph where it dwelt years ago.

The entire season from Easter to Pentecost was once observed as one continuous festival. Later, in the fourth century, the season was separated into the Resurrection, the Ascension, and Pentecost.

The early church called Easter *Pascha,* a word derived from the Hebrew for Passover. The name Easter comes from the Anglo-Saxon spring goddess, Eostre, whose festival coincided with the spring equinox.

General Character:

Easter Day is the most important day of the church year. "Christ is risen! Alleluia!" The resurrection is the keystone in the arch of Christianity. Without it, everything else crumbles. Christians moved their day of worship from the last day of the week to the first so that each Sunday is a "little Easter." Sundays are never fast days, even during Lent.

Ascension Day falls near the close of this season. As determinded from Scripture, it is the fortieth day after Easter, always a Thursday.

Color:

The color for the Easter season is *white.*

Symbols:

By accident or by design, symbols for Easter tend to use as their forms things which are pleasant in themselves aside from symbolic content. Light, flowers, and birds all have their place along with tokens of victory and kingly estate. Many of the symbols for Easter carry the meaning, not only of the resurrection of Christ, but also of the Christian's ultimate resurrection and eternal life.

Seeds bursting forth from the pomegranate symbolize the power of the Lord who burst forth alive from the tomb. The pomegranate is also symbolic of royalty, hope, and future life. The many seeds of this plant also suggested to artists the unity and oneness in Christ of the many believers, and thus the pomegranate is also a symbol of Christ's church.

■

It is easy to note how a butterfly has become symbolic of the resurrection. The beautiful form of the butterfly coming from the seemingly lifeless chrysalis could hardly fail to suggest itself as a parallel to the Lord's coming forth from the tomb. Also representing the individual Christian's victory through Christ, this symbol offers additional meaning. The larva suggests the lowly condition of man on earth; the chrysalis, the body of man in the grave; the butterfly, the glorified body destined for eternal life.

■

Crowns symbolize kingly estate. Here a crown is used with an alpha and omega to symbolize Christ, the King forever. The alpha and omega are the first and last letters of the Greek alphabet which appear in this passage from Revelation: " 'I am the Alpha and the Omega,' says the Lord God, who is and who was and who is to come, the Almighty" (1:8). These symbolic elements emphasize the joyous message that Christ has risen and reigns forever.

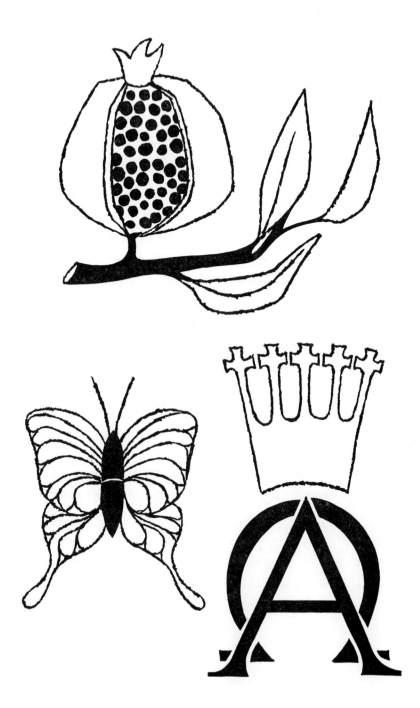

After the phoenix has lived to the age of four or five hundred years, it gathers a nest of sweet smelling twigs and spices. The nest is set on fire by the heat of the sun, and the phoenix is consumed, only to rise from the ashes, recreated and young, starting a new cycle of never-ending life. So goes one variant of the ancient legend of the phoenix bird. Existing since pre-Christian times, this legend gave Christians another symbol for the resurrection of our Lord, and for the resurrection of the faithful.

■

The peacock, although not a mythical bird like the phoenix, owes its use as a resurrection symbol to legend also. Two beliefs concerning the peacock led to its symbolic use. One legend stated that the flesh of the peacock did not decay after death, and another said that the peacock shed its feathers each year only to grow new and more beautiful ones. Ideas of incorruptibility or renewal such as these made the symbol a fitting one. The peacock was commonly represented in the catacombs and in Byzantine art. Two peacocks drinking from a vase, symbolic of the Water of Life, is another variation of the symbol.

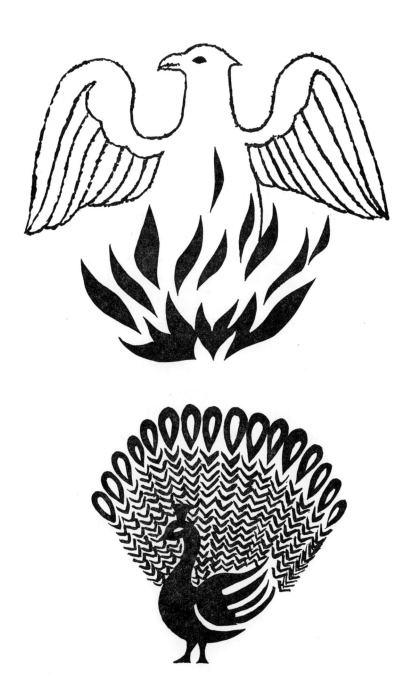

Easter lilies, which form such a large share of church decoration during Easter, are associated with the resurrection for two reasons. The first is simply that they bloom at that time of year, which is always a factor in the association of certain flowers with the various seasons of the church year. Another is the seeming decay of the bulb of the lily until it finally grows and blooms at Easter. A suggestion of the idea of life from death was the basis for the connection of a variety of things with the resurrection.

■

The meaning of the symbol which combines the cross and Greek words is "Jesus Christ the Victor." The four letters on the top are IC and XC, abbreviations for IHCOΥC (meaning Jesus) and XPICTOC (meaning Christ) respectively. The letters below, NIKA, may be translated Victor or Conqueror. The small marks above the IC and XC indicate that these are abbreviations.

■

A symbol composed of the Chi Rho (explained in the chapter on Advent) and an N representing NIKA carries approximately the same meaning as the symbol discussed above.

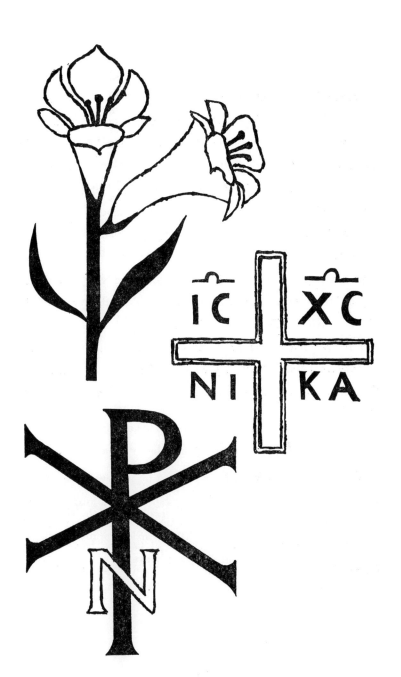

Soaring heavenward, the eagle has given rise to numerous legends and beliefs. One legend states that as the eagle grows old and its eyes become dim, it flies as high as possible and looks directly into the sun. After returning to earth and plunging three times into a fountain, it comes forth with its youth and eyesight restored. On the basis of this legend, the eagle became a symbol for the resurrection. A comparison which is easier to appreciate indicates that the eagle is a symbol for the ascension. It was said that as the eagle soars upward into the clouds, so Christ rose to heaven on the day of his ascension. Again, the eagle symbolizes the renewed life of the individual Christian who has been baptized into the death and resurrection of the Lord. This symbol has its basis in the passage from Isaiah, "But they who wait for the Lord shall renew their strength, they shall mount up with wings like eagles . . ." (40:31).

■

Elijah's ascent to heaven is symbolized by a fiery chariot. Since Elijah's ascent is considered to be a type of Christ's ascension, the fiery chariot is also used to symbolize the latter. "And as they still went on and talked, behold, a chariot of fire and horses of fire separated the two of them. And Elijah went up by a whirlwind into heaven" (2 Kings 2:11).

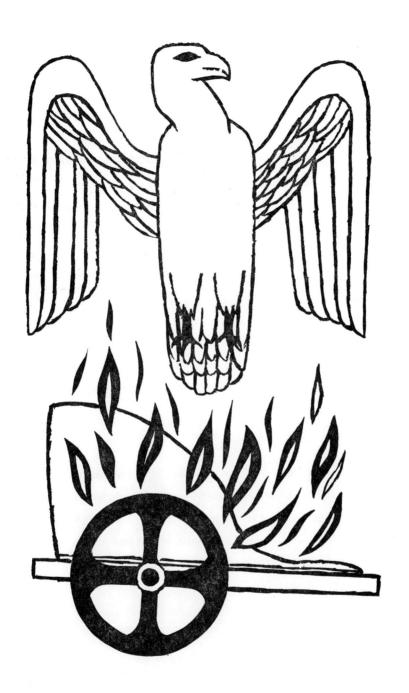

The rather formidable sounding name of this cross is the Cross Triparted Fleurée. Triparted describes the three horizontal and three verticle arms of the cross, and Fleurée describes the endings of the arms which resemble the fleur-de-lis. The emphasis on three and the use of the fleur-de-lis (often used as a Trinity symbol) makes this cross most appropriate for the Trinity season.

PENTECOST-
TRINITY

Length:

The Trinity, or Pentecost, season is the longest season of the church year, occupying the time between Pentecost and the first Sunday in Advent.

There are two ways of viewing this season, hence the discrepancy in title. The Roman Catholics prefer to call this the Pentecost season, referring to the Sundays of this season as Sundays "after Pentecost." Lutherans and Anglicans, on the other hand, celebrate Pentecost but prefer to give this season its name from Trinity Sunday, a week after Pentecost, referring to the Sundays of the season as Sundays "after Trinity."

Origin:

Pentecost means fiftieth day. It was taken over from the Jews, who observed it as a feast at the end of the harvest. Later, the Jews came to associate Pentecost with the giving of

the Law to Moses at Mt. Sinai—in a sense, the founding of the Jewish "church." There is a logical parallel here to the founding of the Christian church on the day of Pentecost.

Pentecost is often called Whitsunday which may refer either to the wearing of white robes by candidates for Baptism or to the old Anglo-Saxon word *wit*, meaning wisdom—an allusion to the outpouring of the "Spirit of wisdom" (Ephesians 1:17).

The Sunday immediately following Pentecost is Trinity Sunday. The first festivals of the early church all commemorated persons or events. Festivals based on doctrines came later. Therefore the festival of the Holy Trinity is a late festival but one of the earliest and certainly the most important of the doctrinal festivals.

General Character:

While the first half of the church year was devoted to the life of Jesus, the second half of the year has been set aside for Christian instruction. The revelation of Father, Son, and Holy Spirit is studied and applied to life.

It was mentioned above that this second half of the church year is called either Pentecost or Trinity. This creates some confusion in that the first Sunday after Trinity in the Lutheran and Anglican Churches occurs on the same Sunday as the second Sunday after Pentecost in the Roman Catholic Church, and so on throughout the season.

One might expect this difference to be in title only, but the propers for the Sundays have been dislocated along with the titles. Lutherans and Anglicans use the historic Gospel readings one week ahead of the Roman Catholics, although the Epistles are usually used on the same Sunday in all three churches. To add to the confusion, the Anglicans use the collects one Sunday later than the Lutherans and Roman Catholics. The introits are used on the same Sundays in the Lutheran and Roman Catholic Churches.

Before the seventh century, there were no special lessons

assigned to these Sundays, except for the festival days. There were, instead, a large number of common masses which could be used as desired. Sometimes attempts were made to divide this long season into shorter divisions. One popular method was to separate the season by the feasts of Sts. Peter and Paul (June 29th), St. Lawrence (August 10th), and St. Michael (September 29th). However, if there ever was some plan to the lessons now used during this season, it is no longer discernible.

Color:

Red is used from Pentecost until Trinity Sunday. Beginning with Trinity Sunday, *white* is used through the First Sunday after Trinity. Then, *green* is used from the Monday following Trinity-I until the First Sunday in Advent. Exceptions to the use of green would be special days on which the appropriate color for the occasion is used.

Symbols:

Symbols which represent the Trinity are now totally abstract and emphasize the unity and equality of the three persons of the Godhead. Early representations attempted to depict the mystery in ways which to us seem amusing and sometimes appalling. The Holy Trinity has been shown as one human body with three heads; in a less peculiar manner, as three men of which one is old, one middle-aged, and one young. Neither of these modes of representation would find much favor today. Generally, the abstract and geometric symbols for the Trinity symbolize the mystery rather than make any attempt to explain it. It is easy to see that the older representations cited above do a certain amount of violence to the idea of distinction between the functions of the Three Persons who are yet One.

By far the most common representation of the Holy Spirit is the form of a dove. The basis for this is entirely scriptural and may be found in the story of the Baptism of Christ (Matthew 3:13-17; Mark 1:9-11; Luke 3:21-22; John 1:31-34).

■

A flame may be used to represent the Holy Spirit and is a particularly apt symbol in relation to Pentecost. "When the day of Pentecost had come, they were all together in one place. And suddenly a sound came from heaven like the rush of a mighty wind, and it filled all the house where they were sitting. And there appeared to them tongues as of fire, distributed and resting on each one of them. And they were all filled with the Holy Spirit and began to speak in other tongues, as the Spirit gave them utterance" (Acts 2:1-4). An extension of this symbolism has led to the representation of the seven gifts of the Spirit as seven tongues of fire. The seven gifts have also been represented, in accordance with the symbolism of the dove, as seven doves.

■

The Menorah, or seven-branched candlestick, is a symbol of Jewish origin and is used by Christians to suggest the seven gifts of the Spirit.

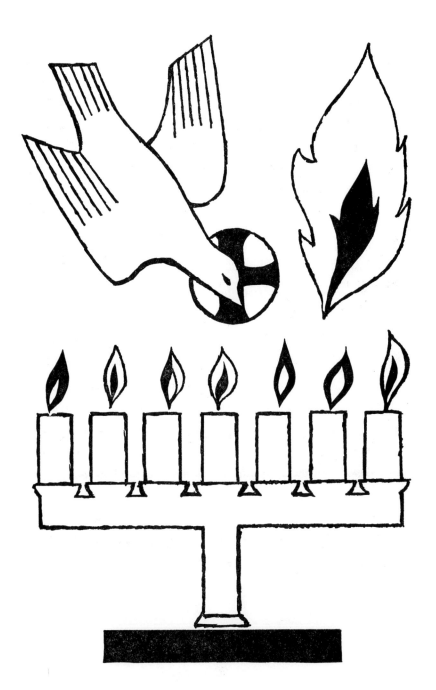

The page opposite contains a number of the various geometric symbols denoting the Holy Trinity. Almost any regular figure containing three distinct equal parts has been used. One of the most common and easily understood of these figures is the equilateral triangle. Many variations on this triple theme are possible and have been used. A Trinity symbol may be used alone or combined with another identical symbol, or the symbol may be combined with a dissimilar one having the same meaning. Any of these three methods may be combined with a circle indicating the eternal nature of the Trinity.

■

Occasionally a Latin Cross is seen combined with the equilateral triangle of the Holy Trinity. The meaning of this combination is that salvation is the work of Jesus Christ, prompted by the love of the Father, and received by man through the work of the Holy Spirit.

■

Other variations which are not shown make use of three fish in a triangle, or a triangle on the sides of which is written, Sanctus, Sanctus, Sanctus—Holy, Holy, Holy.

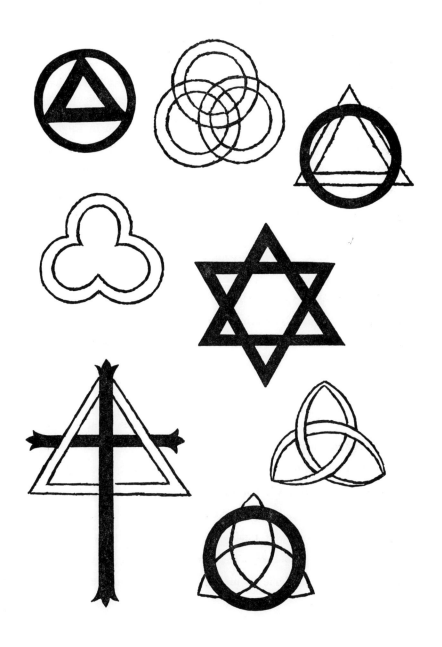

The shield of the Holy Trinity, a symbol found in medieval stained glass, is actually more of a diagram than a symbol. Although triangular in form, the sides of the triangle are curved in such a way as to resemble a shield. The words which are written on the shield usually appear in Latin but have been written in English here for ease of interpretation. The words read logically in any direction one wishes to read them: "The Father is not the Son, The Son is not the Father, The Father is not the Holy Spirit, The Holy Spirit is not the Father"; or, reading diagonally, "The Father is God," and so on.

■

The fleur-de-lis is a symbol for the Holy Trinity and is widely used in this context. The other two meanings of the symbol have already been mentioned in the chapter on Christmas (see page 24).

■

Aside from the obvious triparted form of the shamrock, there is an interesting story behind its use as a Trinity symbol. It is said that when pagans demanded of St. Patrick that he prove that the Trinity is three persons but still one, St. Patrick picked a shamrock leaf. Holding up the leaf, he asked whether he held one leaf or three. His audience was unable to decide. St. Patrick then remarked, "If you cannot explain so simple a mystery as the shamrock, how can you hope to understand one so profound as the Holy Trinity?"

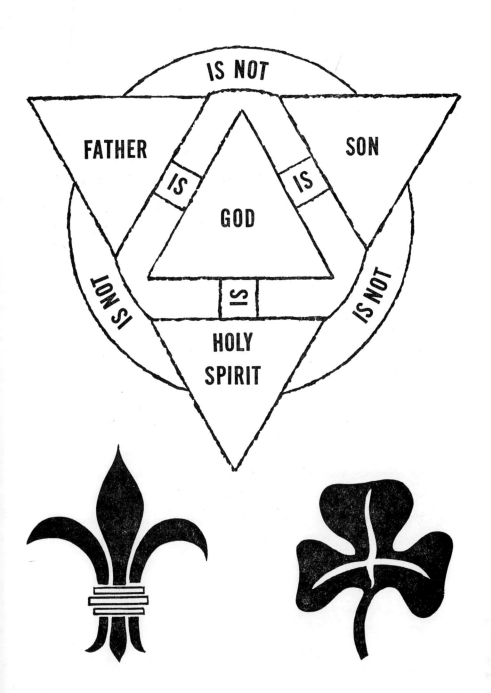

The Cross Flamant is designed in such a way as to suggest that its arms are in flames. This is symbolic of religious zeal, as are fire and flames in general, and it is thus appropriate in connection with the saints.

SAINTS' DAYS
&
HOLY DAYS

Because of the overwhelming number of saints' days that have come into existence from the time of the early church, the Protestant Churches have attempted to select certain important saints' days to be observed. Even now there is no complete agreement. In the Lutheran *Service Book and Hymnal*, for example, the observance of saints' days is limited to the apostles (including Paul), John the Baptist, and the evangelists Mark and Luke.

Aside from these saints' days, a number of holy days have developed commemorating noteworthy events. The Protestant Church has attempted to limit these holy days to those events with a scriptural basis, principally those relating to our Lord. Exceptions to the scriptural basis rule would be Reformation Day and All Saints' Day. Due to the fact that these special days are all fixed calendar dates and do not vary in accordance with the church year, they are listed here in alphabetical order.

Symbols:

Carved and painted figures of the saints were given attributes to distinguish them one from another. These attributes are sometimes displayed alone on a shield, and indicate the saint with whom they are associated. The attempt is made here to show on a shield the most usual attributes for each saint, except in the case of the four evangelists. The use of these attributes frequently stems from the traditional lives of the saints. Since these stories are too long to be included here, the symbols are given with the hope, that the interested reader will seek the reason for the symbols in a more detailed account of the lives of the saints.

ST. ANDREW, APOSTLE—November 30

Andrew was the brother of Simon Peter, both fishermen. Originally Andrew was a disciple of John the Baptist, but John directed him to Jesus as the Lamb of God. Andrew was the first disciple to be called. He also induced his brother to become a follower of Jesus and is therefore considered the first Christian "missionary." According to tradition, Andrew was martyred in Greece by crucifixion on an X-shaped cross, which is now called St. Andrew's Cross. In Christian art, he is usually represented holding or leaning on an X-shaped cross.

ST. BARTHOLOMEW, APOSTLE—August 24

Nothing is known for certain about St. Bartholomew. Some think that Bartholomew was the surname of Nathanael, but this is only a guess. He was led to Christ by Philip. Nothing is known about his death. St. Bartholomew is usually shown with a flaying knife and a book, or with a knife and the devil under foot.

ST. JAMES, APOSTLE—May 1

The festival of St. James coincides with that of St. Philip.
Nothing more is known about this apostle than his name. According to tradition his dead body was sawn asunder, hence
the saw on his shield. Christian tradition has tended to confuse
the three men named James with one another. Christian art
likewise has confused these men. This James is often shown
with a fuller's club, the instrument which caused the death of
a different James. In other cases he has been represented as a
child with a palm branch or with a saw in his hand.

ST. JAMES THE ELDER, APOSTLE—July 25

James the Elder, brother of the Apostle John, son of Zebedee, was one of the earliest of the disciples to be called and was one of the most trusted apostles. He was a fisherman on the Sea of Galilee in partnership with Andrew and Peter. It is possible that his mother was Salome, the sister of Jesus' mother. In that case, James would have been a cousin to Jesus. Called one of the "sons of thunder," James received rebuke from Jesus for the fierceness of his anger and at another time received the indignation of the other disciples for his own ambitions. In Acts we are told of his death by the sword because he incurred the enmity of Herod Agrippa I. He was the first apostle to be martyred and the only apostle to have his martyrdom recorded in the New Testament. Three escalop shells appear on his shield which are in reference to his assumed pilgrimages. In Christian art he is represented as a pilgrim with a staff, or with a staff and wallet, or with a staff and a book.

ST. JOHN, APOSTLE, EVANGELIST—December 27

John the Apostle is traditionally credited with the author-ship of the Fourth Gospel, three epistles, and the Book of Revelation. With his brother James, John was called one of the "sons of thunder." Examples of John's vehemence are given in several places in the New Testament. On the other hand, John was also a man of deep spiritual insight and apparently gained the favor of Jesus for his lovable side. He was one of the three disciples of the "inner circle." From the cross Jesus commended the care of Mary to John. A misunderstanding of the words of Jesus at the Ascension spread the notion that John was not to die. Years later, when the grave which was supposedly John's was opened, only powder was found, and this gave impetus to the tradition that John was taken bodily to heaven. In any event, John is considered the only apostle who died a natural death rather than being martyred. In Christian art John is represented by an eagle, suggesting the soaring loftiness of his writings. Or he is shown with a cup and serpent, or palm branch and scroll. Sometimes he is shown as an old man in vestments being lifted from his grave at the foot of an altar.

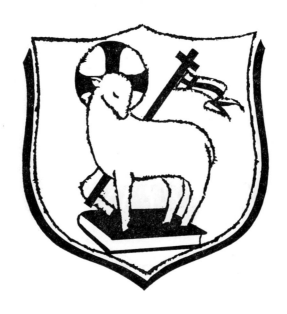

ST. JOHN, THE BAPTIST—Nativity, June 24

The nativity rather than the death of John the Baptist is celebrated as a special day in the church. The promise of John's birth was given to his father, Zacharias, as he was performing his priestly duties in the Temple at Jerusalem. The Angel Gabriel appeared and told him a son would be born to him, and his name was to be John. His mother, Elisabeth, was a cousin to Mary, the mother of Jesus. John was the immediate forerunner of Christ, telling people to prepare the way for the Lord's coming. His ministry was short but highly successful. He was beheaded as a result of the schemes of the adulteress, Herodias. In Christian art John is represented by a lamb on a book, by a lamb and a cross, by a head on a platter, or by a figure of a man dressed in a tunic of camel's hair.

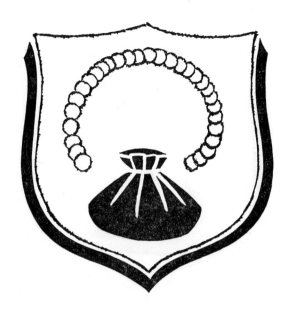

JUDAS ISCARIOT

Judas, of course, was never sainted by the church, nor has any day been set aside in his honor. However, he is included here because there are interesting symbols and representations of Judas which are often used, such as the money bag and thirty pieces of silver as shown. Sometimes a blank shield of an unattractive yellow color is used. Apparently Judas followed Jesus in hopes of attaining a high place in an earthly kingdom. He is considered the antitype of that kind of person who rewards love with treachery.

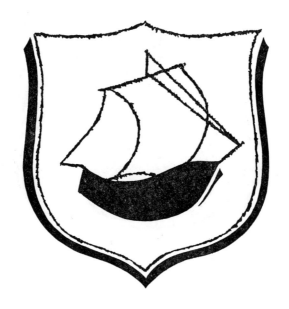

ST. JUDE, APOSTLE—October 28

The festival of St. Jude coincides with the festival of St. Simon. Nothing is known for certain of either of these apostles except that their names are paired together in New Testament listings. They are said to have travelled far together on missionary journeys, hence the boat is used on St. Jude's shield. The date of their festival is the supposed date of their martyrdom. In Christian art Jude is represented with a boat, or boat hook in his hand, or carrying loaves or fish.

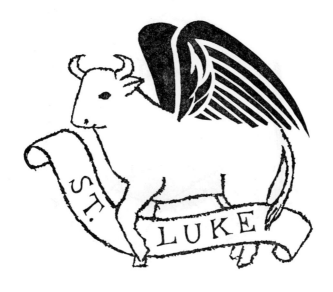

ST. LUKE, EVANGELIST—October 18

Luke was a friend and companion of the Apostle Paul. He has been referred to as "the beloved physician" in one place, and in another place as a fellow laborer with Paul. Other than a few instances, there is really very little information about him that is reliable. He has been credited with the authorship of the Gospel according to Luke and the Book of Acts. In Christian art he is represented by an ox because he gives a full account of the sacrificial death of Jesus. He is also represented with paints and palette, as a physician, or with an ox lying near.

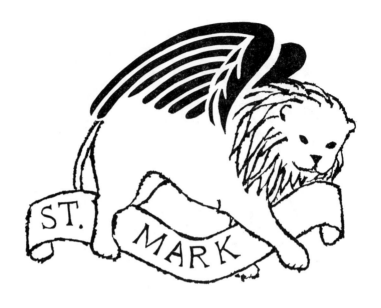

ST. MARK, EVANGELIST—April 25

John Mark is credited with the authorship of the second Gospel. His mother, Mary, was apparently well-to-do, and her house in Jerusalem was a meeting place for the Christians. Mark began as a companion of Barnabas and Paul on their missionary journey, but for some reason left them at Perga and returned to Jerusalem. Whatever the reason for this, Paul disapproved of his conduct so much that he refused to let Mark accompany them when a second journey was proposed. Later, however, Mark appears with Paul in Rome, and it seems that the difference between these men had been removed. Still later, Paul considers Mark "very useful in serving me" (2 Tim. 4:11). Mark is represented by a winged lion because his Gospel begins with a reference to John the Baptist as a voice crying in the wilderness.

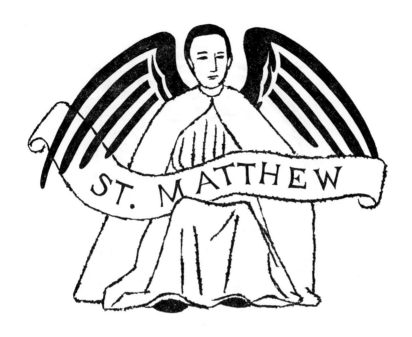

ST. MATTHEW, APOSTLE, EVANGELIST—
September 21

Matthew was a publican and a tax collector. He was called by Jesus to become a follower and immediately left his business to do so. Later he was appointed one of the Twelve. Mark and Luke refer to him as Levi and state that his father's name was Alphaeus. He may have received the name Matthew on becoming a Christian, just as Simon was given the name Peter. Matthew's last appearance in the pages of the New Testament is among the apostles after the resurrection. The first Gospel bears his name. Matthew is represented by a winged man because his Gospel begins with the tracing of the geneology of Jesus. In Christian art he is represented as leaning on a short sword, or with an angel, holding an inkstand, or as an angel with a human face, or with a halbert, book, and inkhorn.

87

ST. MATTHIAS, APOSTLE—February 24

St. Matthias was apparently in the company of the followers of Christ from the time of Christ's baptism and was a witness to the resurrection. He was later selected to fill the place of Judas Iscariot. Nothing more is known of him. In Christian art St. Matthias is represented holding a halbert, or leaning on a sword, or holding a sword by the point, or with a stone in his hand. A book and a scimitar, as shown, is another representation frequently used.

ST. PAUL, APOSTLE—June 29

The festival of St. Paul coincides with that of St. Peter on the strength of the tradition that these two apostles were martyred together. The place and date of this martyrdom, according to tradition, was Rome on June 29th in the year 67 by order of Nero. Another tradition holds that they were martyred on the same date, but each apostle in a different year. And still another tradition places their death on February 22nd in the year 68. Paul was the great apostle to the Gentiles. Unlike some of the apostles who are known by name only, a great deal of information is available about St. Paul. His missionary work is related in Acts and many of his letters appear in the New Testament. St. Paul is represented by three fountains, based on one of the legends surrounding his death.

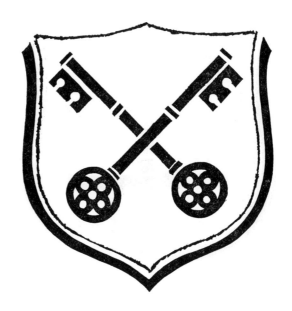

ST. PETER, APOSTLE—June 29

The festival of St. Peter coincides with that of St. Paul. Peter, meaning rock, is the name Christ gave to Simon. Simon was the son of Jona, a fisherman on the Sea of Galilee. It is believed that Peter was a disciple of John the Baptist. After becoming a follower of Jesus, his courage, vigor, sincerity, and other qualities marked him as the leader among the disciples. After the foundations of the church had been established, Peter seems to have taken a place in the humble laborings for the kingdom and disappears from the pages of the New Testament. John 21:19 hints that Peter died a martyr's death. Tradition places his death in Rome. The meaning of the two keys used on his shield derives from Matthew 16:13-19.

ST. PAUL, APOSTLE—June 29

The festival of St. Paul coincides with that of St. Peter on the strength of the tradition that these two apostles were martyred together. The place and date of this martyrdom, according to tradition, was Rome on June 29th in the year 67 by order of Nero. Another tradition holds that they were martyred on the same date, but each apostle in a different year. And still another tradition places their death on February 22nd in the year 68. Paul was the great apostle to the Gentiles. Unlike some of the apostles who are known by name only, a great deal of information is available about St. Paul. His missionary work is related in Acts and many of his letters appear in the New Testament. St. Paul is represented by three fountains, based on one of the legends surrounding his death.

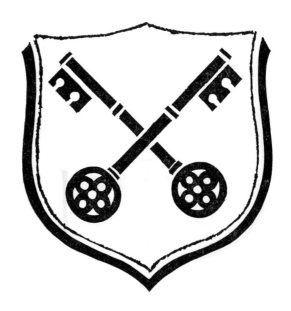

ST. PETER, APOSTLE—June 29

The festival of St. Peter coincides with that of St. Paul. Peter, meaning rock, is the name Christ gave to Simon. Simon was the son of Jona, a fisherman on the Sea of Galilee. It is believed that Peter was a disciple of John the Baptist. After becoming a follower of Jesus, his courage, vigor, sincerity, and other qualities marked him as the leader among the disciples. After the foundations of the church had been established, Peter seems to have taken a place in the humble laborings for the kingdom and disappears from the pages of the New Testament. John 21:19 hints that Peter died a martyr's death. Tradition places his death in Rome. The meaning of the two keys used on his shield derives from Matthew 16:13-19.

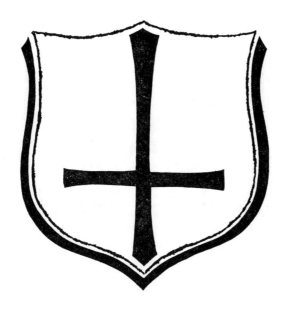

ST. PHILIP, APOSTLE—May 1

The festival of St. Philip is celebrated together with the festival of St. James. Philip's home was in Bethsaida on the Sea of Galilee. Jesus met him at Bethany beyond the Jordan where John the Baptist was baptizing and called him to be a disciple. Philip was also responsible for bringing Nathanael into the company of the Master. After the resurrection, Philip was among the apostles who met in the upper room. This is the last we hear of him directly. In Christian art Philip is represented with a basket in hand (since the Master directed his inquiry to Philip at the feeding of the multitude), or with two loaves and a cross, or with a Tau Cross and book, or crucified upside down. An inverted cross is shown on his shield.

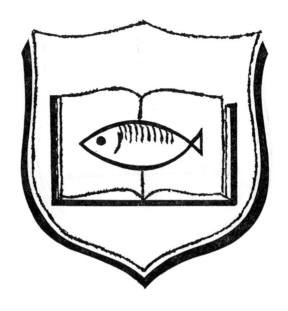

ST. SIMON, APOSTLE—October 28

The festival of St. Simon (not to be confused with Simon Peter) is celebrated together with St. Jude. Nothing is known of Simon beyond tradition. In Christian art St. Simon is represented by a fish on the leaves of an open book as shown, with a fish in hand, with an oar, or as a man sawn through lengthwise.

ST. STEPHEN, MARTYR—December 26

St. Stephen was the first Christian martyr. He was a notable person and became conspicuous as an outstanding preacher and worker of miracles. Later he was charged with blasphemy and brought before the Sanhedrin, or supreme Jewish council. In the midst of his defense argument before the council, Stephen suddenly stopped his argument and bitterly charged the council with resisting the Holy Spirit, just as their fathers had resisted. The events finally stirred them up so that they seized Stephen, rushed him out of the city, and stoned him. Without Roman authority, it was unlawful for the Sanhedrin to put anyone to death, so Stephen's martyrdom must have been the result of an uncontrollable outbreak. The speech and death of Stephen are said to mark the transition from a Jewish-Christian fellowship to its extension among the Gentiles. St. Stephen is represented by stones and a book.

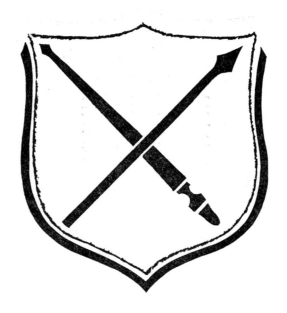

ST. THOMAS, APOSTLE—December 21

St. Thomas was also called Didymus, a Greek name meaning twin. Thomas has come to be designated as "doubting Thomas" because of his words: " 'Unless I see in his hands the print of the nails, and place my finger in the mark of the nails, and place my hand in his side, I will not believe' " (John 20:25b). St. Thomas is represented by a spear and lance.

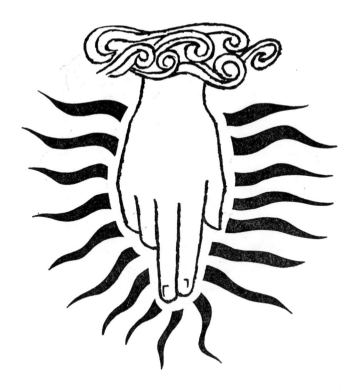

ALL SAINTS' DAY—November 1

At a very early date the church set aside a day for all martyrs. At first this celebration was held on May 13th. In the mid-ninth century the date was shifted to November 1st, perhaps due to the fact that in May the food supply could not care for all the pilgrims who journeyed to Rome for this popular feast. All Saints' Day is considered a major festival in the Lutheran Church, although it has often been overshadowed by Reformation Day which falls on the previous day.

All Saints' Day may be symbolized by the Hand of God. This symbol embodies the idea that the hand of God is over the souls of the righteous.

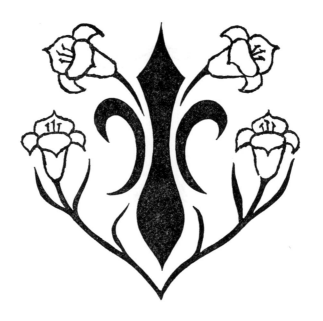

THE ANNUNCIATION—March 25

This festival is based on Luke 1:26-38 in which it is related that the Angel Gabriel announced to Mary that she would bear the Messiah. The date for this festival is placed nine months prior to Christmas. In the Roman Catholic Church the emphasis of this day is placed on the Virgin Mary rather than on the announcement of the Incarnation.

The lily may be used as a symbol of the Annunciation. It appears in almost all representations of the Annunciation and has come to symbolize the purity and virginity of Mary. One authority thinks the presence of a flower in early representations is due to the fact that the medieval church taught that the Annunciation took place in the spring, the time of flowers.

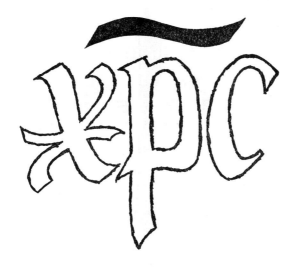

THE CIRCUMCISION AND THE NAME OF JESUS—
January 1

"And at the end of eight days, when he was circumcized, he was called Jesus, the name given by the angel before he was conceived in the womb" (Luke 2:21). This was done according to the ritual of the Jews. January 1st was set aside to commemorate this event in the octave of Christmas. The church makes no reference to the beginning of the civil calendar on this date.

A monogram for Christ may be used to represent this day. The Chi Rho and IHC symbols have already been discussed, and a form of either would be appropriate. One type of the Chi Rho is shown here.

THE CONVERSION OF ST. PAUL—January 25

Certainly the conversion of St. Paul was one of the most momentous events of the early church. It is related in Acts 9:1-22, Acts 22:3-21, and Acts 26:9-20. Because of the fact that the risen Lord appeared to him in this manner, Paul considered himself one of the chosen apostles.

The conversion of St. Paul might be marked by one of the symbolic renderings of St. Paul's attributes such as is shown here. This symbol is a shield of faith. As Paul said, "Put on the whole armor of God . . . above all taking the shield of faith, with which you can quench all the flaming darts of the evil one" (Ephesians 6:10-16).

THE HOLY INNOCENTS, MARTYRS—December 28

After being tricked by the Wise Men, Herod was enraged that he had not learned the whereabouts of the Christ Child. As a result, he ordered a wholesale slaughtering of all male children up to two years of age in the region of Bethlehem. In the process he hoped to slay the Holy Child (Matthew 2:16-18). At a very early date the church set aside a day to commemorate the slaying of these children who were unwitting martyrs for the Christ.

A fitting symbol for this day might be the combination of the sword and palm which appears with so many martyrs. The sword symbolizes martyrdom or violent death, and the palm connotes victory or heavenly reward.

THE PRESENTATION OF OUR LORD—February 2

"And when the time came for their purification according to the law of Moses, they brought him up to Jerusalem to present him to the Lord (as it is written in the law of the Lord, 'Every male that opens the womb shall be called holy to the Lord') and to offer a sacrifice according to what is said in the law of the Lord, 'a pair of turtledoves, or two young pigeons'" (Luke 2:22-24; for Old Testament references, cf. Exodus 13:2, 12 and Leviticus 12). The Presentation is symbolized here by two doves in a small cage.

According to Luke 2:22-35, the Holy Spirit had revealed to the aged Simeon that he would not see death until he had seen the Christ. On discovering the parents with the child Jesus, he uttered the well-known *Nunc Dimittis* (Luke 2:29-32) which is now a part of the Communion Service. In the Roman Catholic Church, the Presentation is a feast to the Virgin Mary.

REFORMATION DAY—October 31

It was on October 31st, the eve of All Saints' Day, in 1517 that Luther nailed his Ninety-five Theses to the church door at Wittenberg. Luther's sole intent was to debate abuses within the church. He had no idea he was starting the Reformation. Indeed, Luther himself would undoubtedly object to a celebration commemorating such a serious division within the church of Christ. However, the popularity of this festival seems to demand its continuation in the Protestant Church.

A symbol which might be used in connection with Reformation Day is the lamp, symbolic of Christian knowledge. Luther's action brings to mind the search of every Christian for knowledge of the truth.

ST. MICHAEL AND ALL ANGELS—September 29

Otherwise known as Michaelmas, this is the only festival regarding angels in the Lutheran calendar. Michael and his angels are referred to in Revelation 12:7-12 as the champions against Satan, whom they cast out of heaven.

St. Michael and All Angels may be represented by a sword and scales. St. Michael is said to weigh the souls of men in a scale; however, this has no scriptural basis. St. Michael, whose name means "who is like unto God," is the leader of the arch-angels. There are seven archangels: In addition to St. Michael, there are Gabriel (meaning strength of God), Raphael (God heals), Uriel, Chamuel, Jophiel, Zadkiel.

Then there are nine choirs of angels which are divided into three hierarchies: Counselors, Governors, and Messengers. The choirs composing the Counselors are Seraphim, Cherubim, and

Thrones. The choirs composing the Governors are Dominions, Virtues, and Powers. The choirs composing the Messengers are Princedoms, Archangels, and Angels. These nine choirs of angels range around the throne of God, praising him. In the case of the Messengers, they act as a means of communication between God and man.

Reference is made to the choirs of angels in such hymns as *Ye Watchers and Ye Holy Ones:*

> *Ye watchers and ye holy ones,*
> *Bright seraphs, cherubim, and thrones,*
> *Raise the glad strain, Alleluia!*
> *Cry out, dominions, princedoms, powers,*
> *Virtues, archangels, angels' choirs,*
> *Alleluia!*

Originally angels were not represented with wings. They were sexless beings identified as messengers by a staff. The winged, female angels derive from a combination, or confusion, of Hebrew ideas with the winged victories of the Greeks.

THE TRANSFIGURATION OF OUR LORD—August 6

The Transfiguration has been celebrated since the ninth century in the Western Church. In 1457, Pope Calixtus III declared the Transfiguration an ecumenical feast, setting aside August 6th as the date for its observance. Later, many German Lutheran orders placed the Transfiguration on the Sixth Sunday after Epiphany. Both dates are given in the Lutheran calendar, with the note that the Transfiguration propers *may* be used on the last Sunday after Epiphany. This means, in effect, that if August 6th falls on a Sunday, the Transfiguration may occur twice in the year. Or, if August 6th does not fall on Sunday, the Transfiguration may be neglected. A happier solution is needed. The Transfiguration (Matt. 17:1-9; Mark 9:2-10; Luke 9:28-36) seems to mark the time after which Jesus set his sights toward Jerusalem.

To symbolize the Transfiguration, a crown surrounded by rays of glory has been used. The Transfiguration was a glimpse of Christ's coming glory as the Son of God and King and was a hint of his ultimate victory.

THE VISITATION—July 2

The Visitation is the only festival concerning the Virgin Mary which has found its way into the Lutheran calendar. It is rejected by the Anglicans. The reason it is retained in the Lutheran Church is its scriptural basis and the *Magnificat* of Mary. When it was revealed to Mary that she was chosen to bear the Christ, it was also revealed to her that her kinsman, Elizabeth, was six months pregnant with a son (John the Baptist). Mary went quickly to visit Elizabeth in a city of Judah. "And when Elizabeth heard the greeting of Mary, the babe leaped in her womb. . . . And Mary said, 'My soul magnifies the Lord . . . '" (Luke 1:39-56). This *Magnificat* of Mary is considered one of the most beautiful of the New Testament psalms.

The Visitation is symbolized very simply by the heads of two small children.

BIBLIOGRAPHY

Seasons, Saints' Days, and Holy Days:

Davis, John D., *The Westminster Dictionary of the Bible*. Philadelphia: The Westminster Press, 1924.

Denis-Boulet, Noele M., *The Christian Calendar*. New York: Hawthorn Books, 1960.

Gwynne, Walker, *The Christian Year*. New York: Longmans, Green, & Co., 1915.

Horn, Edward T., III, *The Christian Year*. Philadelphia: Muhlenberg Press, 1957.

McArthur, A. Allan, *The Evolution of the Christian Year*. London: SCM Press Ltd., 1953.

Reed, Luther D., *The Lutheran Liturgy*, Revised Edition. Philadelphia: Muhlenberg Press, 1947.

Strodach, Paul Z., *The Church Year*. Philadelphia: The United Lutheran Publication House, 1924.

Symbols:

Appleton and Bridges, *Symbolism in Liturgical Art*. New York: Charles Scribner's Sons, 1959.

Ferguson, George W., *Signs and Symbols in Christian Art*. New York: Oxford University Press, 1959.

Kerr, James, *Come and See the Symbols of My Church*. Minneapolis: Augsburg Publishing House, 1960.

Koch, Rudolf, *The Book of Signs*. New York: Dover Publications, Inc., 1955.

Mâle, Emile, *The Gothic Image*. New York: Harper & Bros., 1958.

Stafford, Thomas A., *Christian Symbolism in the Evangelical Churches*. Nashville: Abingdon Press, 1942.

Vincent, Jean Anne, *History of Art*. New York: Barnes & Noble, 1955.

Watts, Alan W., *Myth and Ritual in Christianity*. New York: The Vanguard Press, 1954.

Webber, F. R., *Church Symbolism*. Cleveland: J. H. Jansen, 1938.

Winzen, Damasus, *Symbols of Christ*. New York: P. J. Kenedy & Sons., 1955.

About the Authors

Robert Wetzler is a versatile young man, probably best known as a choral composer. Thirty-nine of his anthems, two vocal solos, and a series of Introits for the Church Year have been published by Augsburg Publishing House.

He was born in Minneapolis in 1932, and attended elementary and high school there. He received a B.A. degree with an English major from Thiel College, Greenville, Pa., in 1954; an M.Div. from Northwestern Lutheran Theological Seminary, where he was awarded a prize for outstanding New Testament studies, in 1958; and did graduate study at the University of Minnesota.

Wetzler is a music editor for a Minneapolis publisher which publishes sacred and secular choral works. He is a frequent contributor of articles for the *Journal of Church Music*. Every year since 1967 he has received an award from ASCAP.

Helen Huntington (Mereness) is equally talented in her field as an artist. She helped plan and write *Seasons and Symbols* and made the drawings.

She was born in Dodge Center, Minn., in 1933. She was awarded the B.F.A. degree from the Minnesota School of Art in 1957, attended the University of Minnesota, and worked as a free-lance artist. She has been the recipient of several scholarships.

108